MANET PAINTS MONET

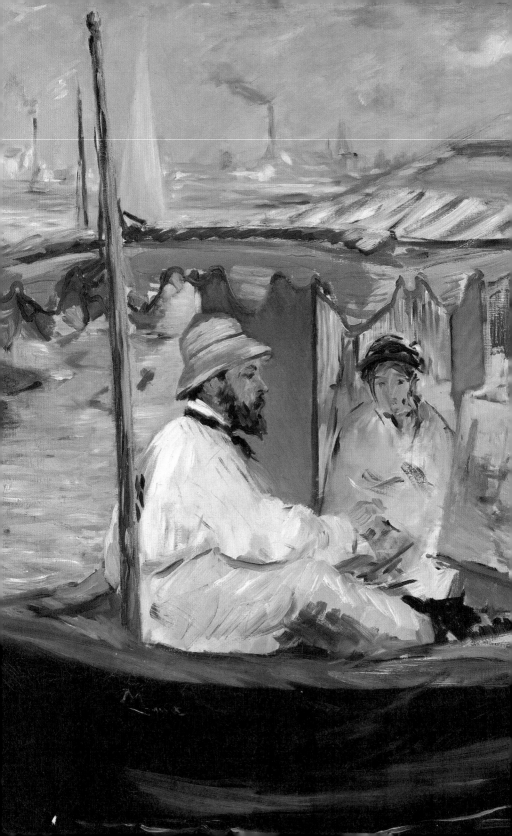

MANET PAINTS
MONET
A SUMMER IN ARGENTEUIL

WILLIBALD SAUERLÄNDER

TRANSLATED BY DAVID DOLLENMAYER

The Getty Research Institute Publications Program
Thomas W. Gaehtgens, Director, Getty Research Institute
Gail Feigenbaum, Associate Director

Originally published in German as Manet Malt Monet: Ein Sommer in Argenteuil, by Willibald Sauerländer © Verlag C. H. Beck oHG, München 2012

English translation © 2014 J. Paul Getty Trust
Published by the Getty Research Institute, Los Angeles
Getty Publications
1200 Getty Center Drive, Suite 500
Los Angeles, California 90049-1682
www.getty.edu/publications

Nola Butler, Manuscript Editor
Catherine Lorenz, Designer
Stacy Miyagawa, Production Coordinator

Printed in China

18 17 16 15 14 5 4 3 2 1

Library of Congress Cataloging-in-Publication Data
Sauerländer, Willibald, author.
[Manet malt Monet. English]
Manet paints Monet : a summer in Argenteuil / Willibald Sauerländer ; translated by David Dollenmayer.
 pages cm
Includes bibliographical references.
ISBN 978-1-60606-428-3
1. Manet, Édouard, 1832–1883—Homes and haunts—France—Argenteuil.
2. Monet, Claude, 1840–1926—Homes and haunts—France—Argenteuil.
3. Monet, Claude, 1840–1926—Friends and associates. 4. Painting, French—France—Argenteuil—19th century. 5. Plein air painting—France—Argenteuil—19th century. 6. Neo-impressionism (Art)—France—Argenteuil—19th century.
I. Dollenmayer, David B., translator. II. Title.
ND553.M3S2813 2014
759.4—dc23
 2014022754

Cover and frontispiece: Édouard Manet, The Boat (Claude Monet in His Floating Studio), 1874, oil on canvas. Munich, Neue Pinakothek.

JUNE 2015

CONTENTS

The catastrophe known as the Franco-Prussian War, frivolously precipitated by Napoleon III, struck at the heart of France. The humiliating military defeat at the Battle of Sedan, the cruel siege of Paris during the winter of 1870 to 1871, the Paris Commune and its bloody suppression in 1871, and finally, the loss of the beloved Alsace-Lorraine and the steep indemnity payments imposed on the defeated country by the Treaty of Frankfurt traumatized France. The aged Honoré Daumier, still drawing illustrations for the satirical journal Le Charivari, gave eerie expression to the numb stupefaction of a country that had been in the grip of full-throated patriotic fervor when the war began. A Landscape in 1870 shows an abandoned cannon with its thick black barrel pointed toward a ruined terrain (fig. 1). It is a bitter indictment of the disastrous war incited by the despised monarchy. Another Daumier illustration, which appeared after the armistice of 28 January 1871, shows the corpse of a defeated France laid out on a shield while crows flap through the sky above an empty, devastated landscape (fig. 2). Here we find ourselves very far indeed from the brilliance and luxury, the frivolity and promise of sensual happiness we associate—with some justification but also out of careless, bedazzled habit—

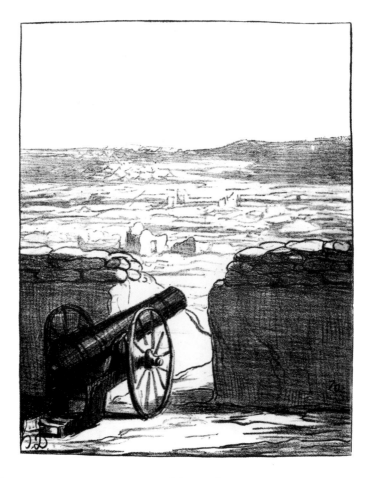

Fig. 1.
Honoré Daumier, *A Landscape in 1870*, lithograph. From *Le Charivari*, 10 December 1870.

with modern French painting between the last decade of the Second Empire and the first decades of the Third Republic (ca. 1860–90). The war and the siege of Paris had also disrupted the artistic life of the capital. Most of the painters in their thirties and forties who in 1860 had begun to deviate from the official art of the Salon—the *indépendants* and *refusés* about whom there was so much talk—were far from the city. Paul Cézanne had holed up in his

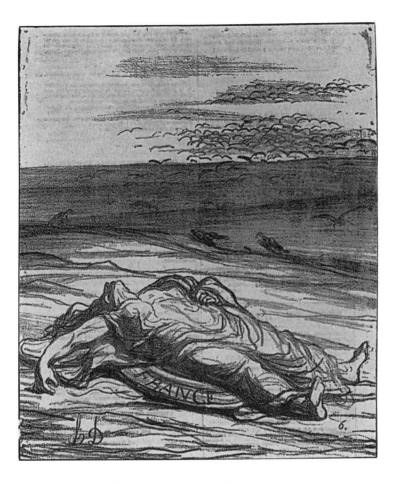

native Provence and was regarded with suspicion as a sort of conscientious objector. Camille Pissarro, who held a Danish passport, withdrew to London. Claude Monet will be discussed below. Others served in the war. Frédéric Bazille was twenty-nine years old when he died in the Battle of Beaune-la-Rolande in November 1870. Pierre-Auguste Renoir was drafted into the cavalry and stationed in the south of France.

Fig. 2.
Honoré Daumier, *Other Candidates*, lithograph. From *Le Charivari*, 3 February 1871.

9

Only the two most prominent *peintres de la vie moderne* (painters of modern life) remained in the besieged capital: Edgar Degas and Édouard Manet. In the hour of danger, Manet behaved not like a bohemian or like an escapist, as did his friend Zola, but instead acted like an ordinary bourgeois patriot. In the first days of September 1870, he sent his mother, his wife, and his son, Léon Leenhoff, to safety in Oloron-Sainte-Marie in the Pyrenees. Meanwhile, he volunteered for the National Guard, where he served until the end of the siege of Paris on 28 January 1871. The letters he sent to his wife during this period, despite their calm, composed tone, are among the most touching testimonies to the sufferings of the freezing, hungry inhabitants of Paris.[1] Apparently, he painted hardly anything during this time, although he wrote his wife that he kept his painting implements in his rucksack. We know of only one painting from this period, a winter landscape showing the village of Montrouge, south of the capital, painted around 20 December 1870. It is a hasty sketch of gray—or more precisely, brownish—forlornness that captures the dreary mood of the besieged metropolis, lying as if beneath a shroud (fig. 3). There is no trace of the radiance we expect from Impressionist paintings. The only other work of Manet's we have from the time of the siege is an etching that shows a line of Parisians waiting in front of a butcher shop on a rainy day: women bundled up in winter clothes beneath umbrellas (fig. 4). On 19 November, Manet wrote to his friend, the painter Eva Gonzalès, "A piece of horse meat is a great joy. Donkey is unaffordable. There are butchers for dogs, cats, and rats."[2] Even in this time of privation, Manet remained an alert, sensitive observer of the life of the big city. He sharpened the graphic technique he learned from James McNeill Whistler and applied it to a somber shadow play of hunger, rain, and cold.

Two lithographs by Manet of Paris in 1871 are of another caliber entirely. They bear emphatic witness to the political engagement

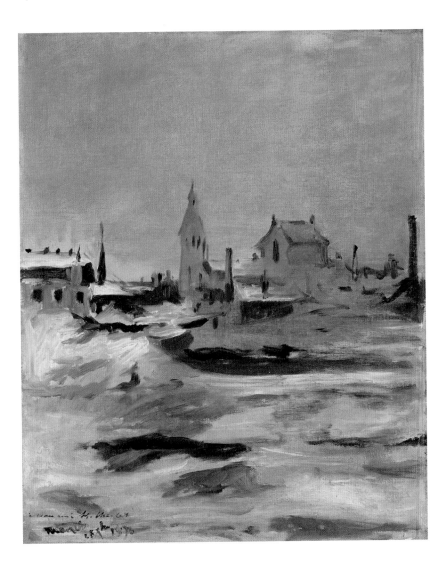

Fig. 3.
Édouard Manet, *Effect of Snow at Petit-Montrouge*,
end of December 1870, oil on canvas. Cardiff,
National Museum Wales.

of a citizen and patriot who, like most writers and artists of the time, was a staunch republican. The small print with the title

The Barricade shows a Paris street corner where government troops are shooting down Communards at close range (fig. 5). In the second lithograph, *Civil War*, we see two corpses lying on the ground before a stone wall like black shadows. Both prints reflect the atrocities

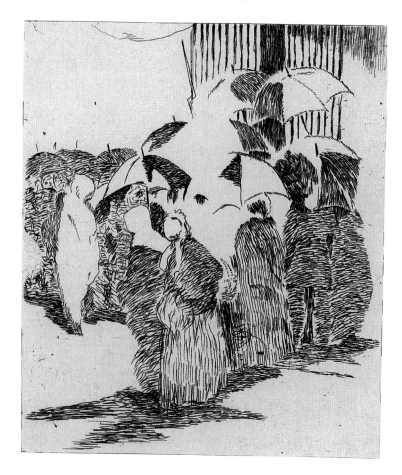

12

Fig. 5.
Édouard Manet, *The Barricade*,
1871, lithograph.

committed during the *semaine sanglante* (bloody week), 21–28 May 1871, when the troops of the Thiers government entered Paris and slaughtered twenty to thirty thousand Communards in a blood lust of official terror. We do not know for certain whether Manet was in Paris at the time, but the answer to that question is not crucial. His partisanship for the population in the face of the brutality with which the Commune was put down by the forces of law and order is beyond doubt.

Manet's earlier images of violent death—such as *The Dead Toreador* (1864/65), or *The Execution of Emperor Maximilian of Mexico* (1867)—are now brought up-to-date in fictive reportages of the street fighting in a politically divided Paris, and his previous aesthetic detachment is abruptly transformed into outrage and indictment. Both prints had to be concealed from the censor. *Civil War* was not published until 1874 and *The Barricade* did not appear until after Manet's death.[3] These two prints demonstrate how radically he had divorced himself at this moment from any notion of l'art pour l'art as well as any historicizing reference to earlier painting, and how deeply affected he was by the tragedy of his defeated *patrie*, now plagued by civil war.

Alongside these images there are quite different ones from these months, pictures that reflect Manet's depressed mood after the disastrous outcome of the war. In February 1871, he traveled to the Pyrenees to fetch his family. Not wanting to return to Paris immediately, they spent a month at the seaside in Arcachon near Bordeaux. Manet painted a few hurried, joyless views of the coast (fig. 6). They show no sunshine, only a drab late-winter landscape: a deserted shore with bare trees against a gray sky. The Manets had rented a chalet with a view of the sea. Like peep shows, the windows and verandas of the ugly holiday houses give onto the outdoors. Except for these views, their rooms are filled with vacation boredom and leaden time killing. Their inhabitants stare at nature

14

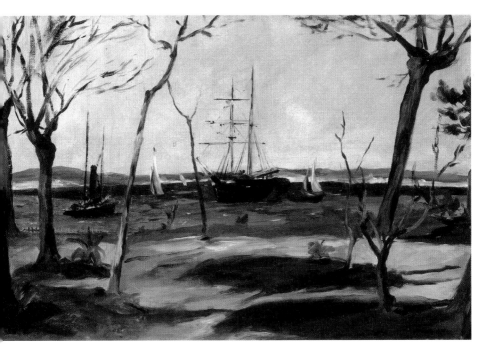

but remain cut off from it, as if in a cage. Manet captured this alienated mood in a painting of unforgettable ennui (fig. 7). In the middle of a rented salon stands a heavy, unwieldy table—a hideous piece,

Fig. 6.
Édouard Manet, The Bay of Arcachon, 1871, oil on canvas. Zurich, Foundation E. G. Bührle Collection.

probably of mahogany. Madame Manet sits in an armchair on the left and gazes at the sea through the open porte-fenêtre but also appears to be lost in thought over some writing in her lap. Her son, Léon Leenhoff, has taken a seat across the table from her. He sits casually, one leg crossed over the other, and seems to have forgotten the book or notebook that lies open on his thigh. He toys with the fountain pen in his raised right hand. With his head tilted slightly back, the young man muses on his daydreams. The painting bears the prosaic title Interior in Arcachon. It

15

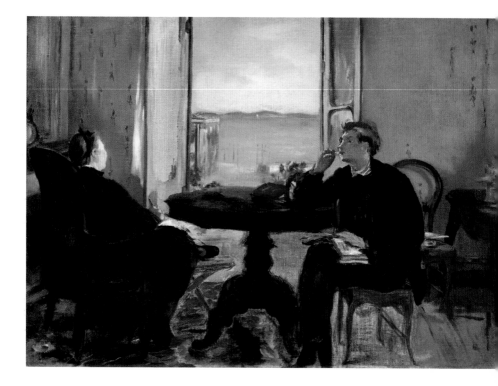

Fig. 7.
Édouard Manet, *Interior in Arcachon*, 1871, oil on canvas. Williamstown, Massachusetts, Sterling and Francine Clark Art Institute.

might have been more appropriately titled *Ennui* or *Vacances*. The desolate mood that followed the lost war, the discomfort of the rented rooms, the urban visitors' ambivalent relationship to nature, both nostalgic and inhibited—Manet has drawn together all these aspects in one of the most powerfully expressive yet completely unromantic window paintings of the bourgeois century.[4]

Yet how infinitely far this is from the vibrant color and light of plein air painting, commonly thought of as the progressive signature of Impressionism. Nor were the following years of 1872 and 1873 among the most brilliant of Manet's career. In 1873, he

16

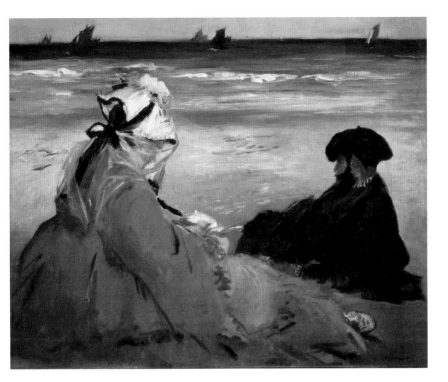

sent to the Salon what was perhaps his
most ordinary painting, *The Good Glass
of Beer*, which in the spectrum of depic-
tions of the *vie moderne* actually represents
an artistic and social lapse. In 1873, he

again took his family to the sea, this time to Berck-sur-Mer on the
English Channel. There, too, he painted. In the famous *On the Beach*,
we again see his wife, Suzanne, who here sits on the beach with
the painter's brother, Eugène (fig. 8). Manet probably painted the
picture outside. His subject is no longer a view from a room, but a
vacation outing under an open sky. Yet the figures are still bundled
up against the wind and sand, and absorbed in their own thoughts.
They look like silhouettes in a Japanese woodcut.

17

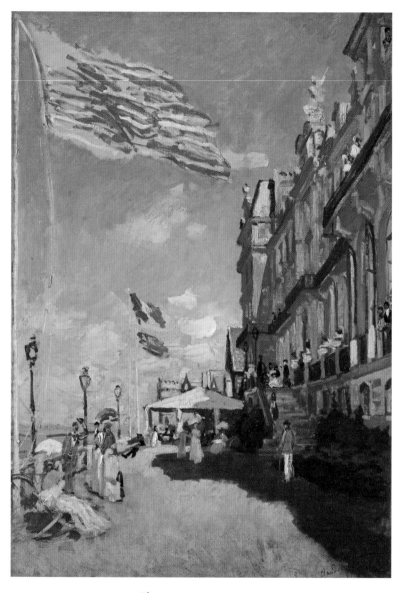

Fig. 9.
Claude Monet, *Hôtel des Roches Noires, Trouville,*
1870, oil on canvas. Paris, Musée d'Orsay.

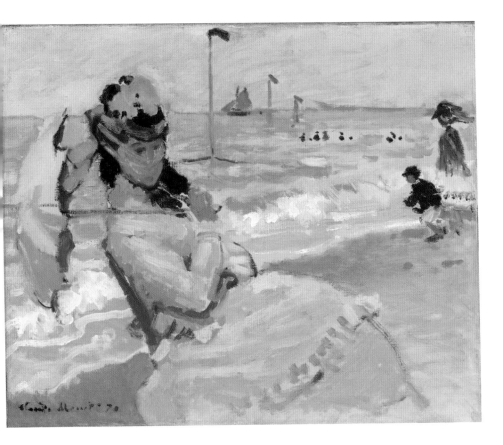

The liberation—the conversion to light glinting off water and to summer— would not occur until the following year, 1874, when Manet vacationed that August in Gennevilliers. He visited Monet at his home in nearby Argenteuil on the opposite bank of the Seine and watched him painting in his atelier boat. Manet had been known to occasionally make fun of his colleague, his junior by eight years: "This young man claims he paints *en plein air* as if the old masters had never dreamed of such a thing."⁵ But now he is fascinated

Fig. 10.
Claude Monet, *Camille on the Beach at Trouville*, 1870, oil on canvas. New Haven, Yale University Art Gallery.

19

by Monet's plein air painting and allows the younger man to open his eyes to light and water. Manet's friend, the journalist Antonin Proust, reported on Manet's expression of admiration for Monet: "There is not another painter from the entire Barbizon school who can get down a landscape as he can. And then the water! He is the Raphael of water. He knows it in its movements, in all its depths, at all its hours."[6] And with that, we approach our actual topic. But first we must trace the paths Monet's work had taken since 1870.

After Monet married his longtime mistress Camille Doncieux on 28 June 1870, the couple spent a few weeks in Trouville on the Normandy coast. Originally a small fishing village, Trouville became well-known when artists from Paris began in 1830 to paint scenes on its beach, an innovative subject that soon proved highly marketable. Then came writers like Alexandre Dumas and Gustave Flaubert. During the Second Empire, Trouville acquired the reputation of a fashionable vacation town for Parisian high society. There, Monet found himself in more elevated social surroundings than those in which he usually moved, and the beachside scenes he painted during these obviously happy days have a kind of jaunty elegance. They are light and bright. A view of the facade of the luxurious Hôtel des Roches Noires with its beachfront promenade and flaneurs and hotel guests looking at the water from their balconies has an almost Proustian atmosphere (fig. 9). Another picture, of Camille nonchalantly seated on the shore in a pale yellow dress with a parasol, is like a daydream of the carefree life of the well-to-do on holiday and seems enchantingly ephemeral and not quite real (fig. 10). Yet what a brilliant contrast these summer pictures are to the bundled-up ennui of Manet's beach scenes from Arcachon and Berck-sur-Mer.

When France declared war on Prussia on 19 July 1870, Monet left the country, thus adopting an attitude very different from Manet's. Monet, a subtly specialized artist who was interested in nothing in

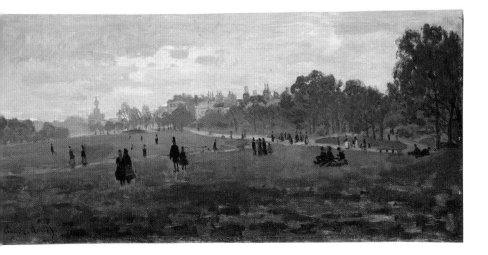

Fig. 11.
Claude Monet, *Green Park, London*, 1870/71, oil on canvas. Philadelphia, Philadelphia Museum of Art.

the world but his painting—which only seldom and in his younger years involved representations of people, but was otherwise nearly always about landscape and water, sky and light—was not made to fulfill the "normal" duties of a citizen. He fled to London. In the time he spent there, he painted only a few pictures, but they are eloquent works: a view of Green Park with a surprisingly witty feeling for the whimsical social fauna in the public gardens of the English capital (fig. 11) and a spectacular view of the Thames from the Embankment (fig. 12). The pier in the foreground, the ships on the river, the towers and Westminster Bridge in the distance—they all appear as only a haze of color, as shadows in the light. But it is the quintessentially modern paradox of Monet's plein air painting that by means of apparently purely "physical" observation it can conjure an extravaganza of color onto the canvas. A merely "optical" view of an urban panorama—the grand contrast between towers, bridges, and water—allows a new, post-Romantic poetry to shine forth. In this regard, Monet was more

21

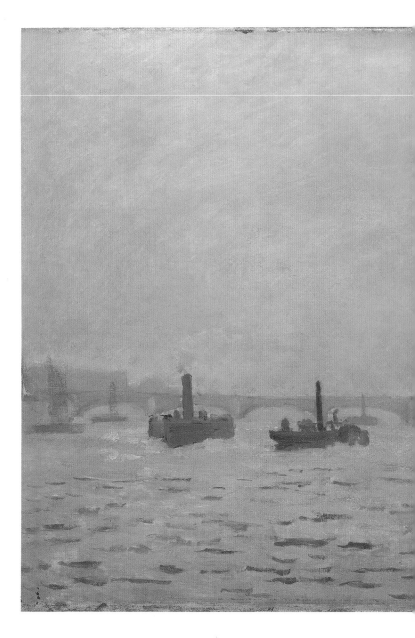

22

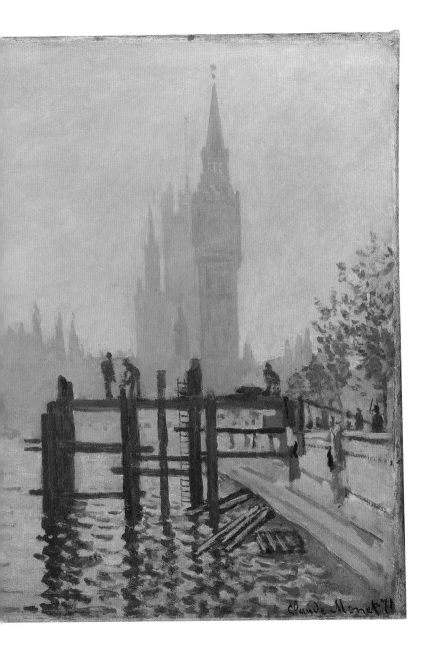

Fig. 12.
Claude Monet, *The Thames below Westminster*, ca. 1871,
oil on canvas. London, National Gallery.

progressive, more modern than Manet, and his specific modernity will occupy us at more length when we come to Manet's picture that shows Monet painting in his atelier boat.

When the Franco-Prussian War ended in February 1871, Monet left London but did not yet dare return to France. Instead, he spent a sojourn of a few months in Holland. Not until November was he back in Paris, where he rented a room in a hotel near the Gare Saint-Lazare while looking for a place to live in the suburbs of the capital, a place where he could combine his business dealings in the city with the ability to paint outside, in the open. Manet, the bourgeois with connections here and there, procured for his friend a house

Fig. 13.
Map of Argenteuil, ca. 1875. From Paul Hayes Tucker, *The Impressionists at Argenteuil,* exh. cat. (Washington, D.C.: National Gallery of Art, 2000), 17, no. 7.

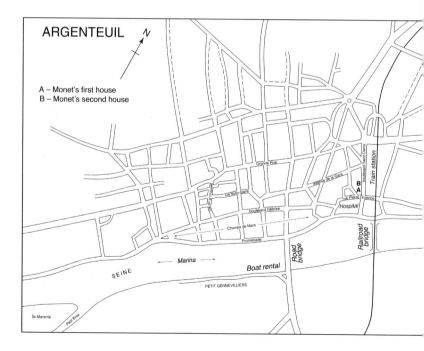

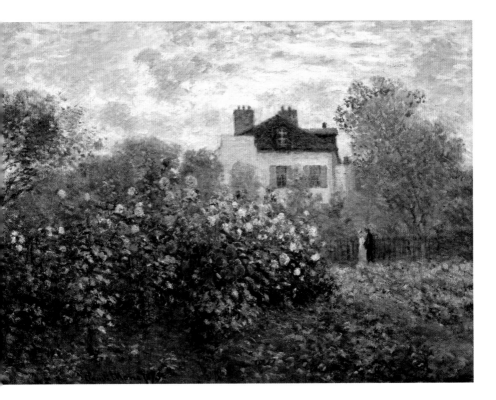

with a garden in Argenteuil on the Seine, downstream from Paris, where Monet installed himself with his family at the end of 1871 and lived until the autumn of 1874. There is at least one old photograph of the *maison*, which no longer exists. Its location on boulevard Saint-Denis is

Fig. 14.
Claude Monet, *The Artist's Garden in Argenteuil (A Corner of the Garden with Dahlias)*, 1873, oil on canvas. Washington, D.C., National Gallery of Art.

marked on a map of the town (fig. 13). But it is above all Monet's own paintings that capture the enchantment that must have been cast on this house by its blooming garden (fig. 14). The eye is entranced by the flowers' riot of color. It is like a paradise of the new plein air style.[7]

25

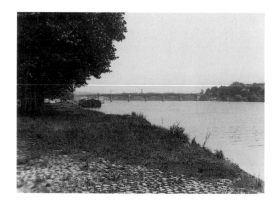

Fig. 15.
Argenteuil (Val-d'Oise),
Bridge on the River Seine,
late nineteenth century,
photograph.

For a brief period after 1872, Argenteuil became a dream locale for the Impressionists, just as Barbizon and the forest of Fontainebleau had been for the landscape painters of French Romanticism thirty years earlier. And yet here, everything is different. That older generation of painters had fled the metropolis for the solitude of nature, fled industrialization in order to paint the peasants. But Argenteuil in the 1870s was already a much-frequented suburb of Paris. The train from the Gare Saint-Lazare could reach it in little more than a quarter of an hour. The trains of the western railway thundered toward Normandy over the Argenteuil railroad bridge, at the lower right on the map of the town (see fig. 13). A second bridge farther downstream carried road traffic and can also be seen on the map. Beside it on the south bank of the river was an anchorage meant not for freight barges but for sailboats and rowboats. Since 1850, Argenteuil had been a center for sailors and rowers from the city. The Paris sailing club had its headquarters there and regattas were held on the river. Monet had not withdrawn into solitude but had instead sought out an intermediate realm that for him combined the best business opportunities with the best working conditions, a point at which the civilization of the metropolis merged with the natu-

26

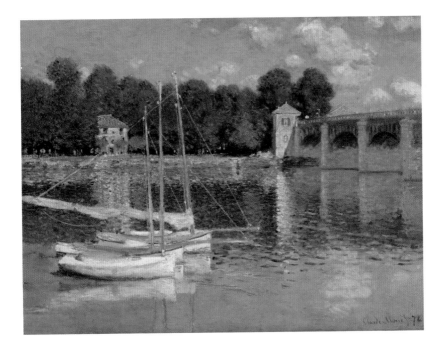

ral beauty of the *banlieue* (suburbs). It was ideal territory for the new plein air painting, a style Monet would bring to its full flowering in Argenteuil.

His subject of choice—his element and his dream—was water: the Seine with its bridges and boat traffic but also its quieter side channel, the Petit Bras, which flows past the overgrown Île Marante, also visible on the town map, in the lower-left-hand corner. Downstream from Paris, the Seine is a quiet, peacefully flowing, and gently poetic river. An old photograph shows what it must have looked like in Monet's day (fig. 15). From the promenade in Argenteuil, one looks across the broad stream. In the distance, the road bridge can be seen with some barges in front of it. In Monet's pictures from 1874, such prospects are transformed into an opalescent play of light and color. The water of the river is the mirror in

Fig. 16.
Claude Monet, *The Bridge at Argenteuil*, 1874, oil on canvas. Paris, Musée d'Orsay.

27

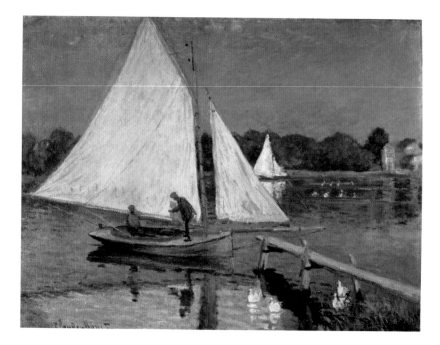

Fig. 17.
Claude Monet, *Sailboats at Argenteuil*, 1874, oil on canvas. Christie's Images Ltd.

which buildings and bridge piers, trees and sailboats are iridescently reflected.

In the painting *The Bridge at Argenteuil* (fig. 16), the location depicted can be identified point by point: on the right is the road bridge with the tollhouse on the north bank, farther to the left, the old ferry house, and in the foreground, the sailboats in the marina. But nothing is stable; all the forms quiver in the light. One is unsure whether this is an actual riverscape or a fata morgana. Another picture painted from the same spot shows the view straight across the river (fig. 17). But now Monet's palette seems to glow. The tonality of the water's surface has a violet tinge, against which the red of the lunging racing shells stands out like a signal next to the opaque, whitish triangles of the sails. These phantasmagorias of color open up a view into spaces of freedom on the periphery of urban society.

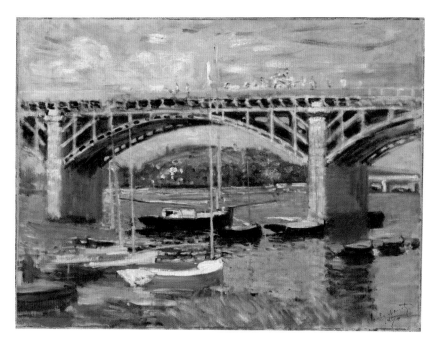

Thus there is something self-evident about the new recreational sports, such as sailing and rowing, appearing as motifs of modern outdoor painting.

Fig. 18.
Claude Monet, *Bridge over the River Seine at Argenteuil*, 1874, oil on canvas. Munich, Neue Pinakothek.

Another aspect of Monet's Argenteuil pictures is the marriage of nature and technology in the bright light of the new plein air style. The bold cast-iron structures and the rolling trains with clouds of steam rising from the stacks of their locomotives are part of the character of the Parisian suburbs. They tell of progress and the belief in the beauty of machines in an age of engineers. Among the significant motifs in Monet's paintings from 1874 are the two bridges across the Seine in Argenteuil, which were quickly rebuilt after having been destroyed in the war. Pride of place belongs to a vivid view of the road bridge (fig. 18). Monet chose a vantage point to the southwest so that the full light

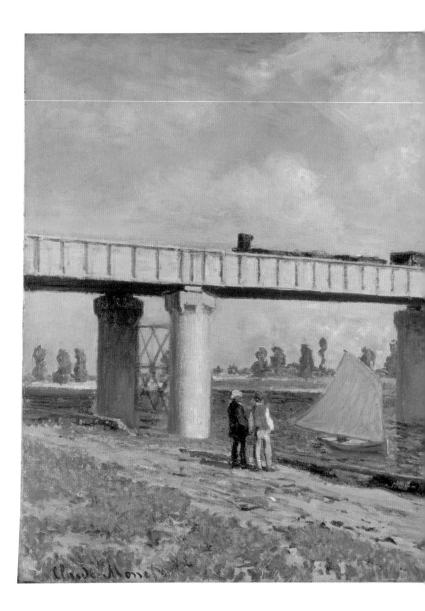

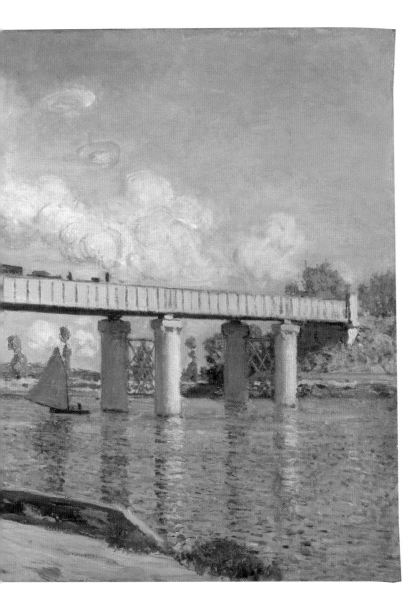

Fig. 19.
Claude Monet, *The Iron Track Bridge at Argenteuil*,
1873, oil on canvas. Christie's Images Ltd.

of a midday summer sun falls on the bridge. The river shimmers in deep blue. Boats lying at anchor in the marina are shown in white or black tones. The bridge piers rise from the water. The lighter blue of the iron arches and struts makes the transition to the color of the cloudy sky. There is something very French about the way civilization and nature, the genius of the structural engineer and the sky and water comport with each other. Landscape here is not Romantic solitude, as it so often is in German painting. Humans interact in this landscape; it is at once natural and man-made.

Other pictures by Monet show the railroad bridge (fig. 19). They capture the view from the north bank of the Seine. The gradations of blue from the water to the sky have a metallic sheen. The round bridge piers between which sailboats glide are mirrored in the river. A train rattles over the rails, the white steam of its locomotive mixing with the clouds. Here landscape is not celebrated as an eternal or idyllic condition; it is the reflection of an instant. Time in this Monet landscape is the time of movement, the brief moment in which a train is hurrying over the bridge at Argenteuil toward the capital.

In Argenteuil, the plein air painter Monet worked almost exclusively outdoors. He set up his easel before his subject in various places, preferably somewhere on the banks of the Seine with a view of boats and barges. It was probably in 1873 that he went a step further. He had a houseboat built and began to paint in this floating atelier. The boat did not survive, but Monet depicted it several times (fig. 20). It was a broad-beamed vessel, painted black, which could be propelled and steered with oars. The bow and forward part were open; farther back rose a fairly tall, boxy cabin, its exterior apparently painted green, with side windows and a slightly vaulted roof to allow rainwater to run off. Fore and aft on its shorter sides, wide doors reminiscent of French *portes-fenêtres* afforded its occupants open views. As a vessel, it must have been fairly unwieldy, but for

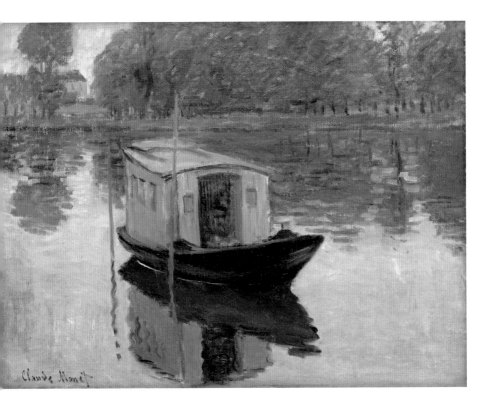

the painter's intentions, it was a highly practical construction.[8]

Monet was not the first artist to build himself such a floating atelier. Charles François Daubigny, a friend of Monet's,

had already made the same experiment as a landscape painter and had sailed extensively on both the Seine and the Oise.[9] Daubigny may have inspired Monet to do the same. But we should not forget that since the end of 1871 Monet himself had been living in Argenteuil, surrounded by sailboats and rowboats. The thought to launch his own atelier among the commercial barges and recreational sailboats and shells may have come to him independently.

He had obviously realized that a floating studio would be the ideal place for his outdoor painting. Floating on the water, surrounded by water, he painted the water. With an easel set up in the cabin, the boat was a seductive refuge for an art that sought to capture no longer the objective corporeality of things but only their vibration in light, their reflections and aquatic mirrorings. Here the plein air painter had neither solid ground underfoot nor any fixed location. As Monet's atelier boat floated slowly and silently along on the river, the riparian landscape passed before his eyes like a film (fig. 21), in correspondence with his paintings, which no longer knew any fixed boundaries and were no longer "composed" in an academic sense.

Monet's favorite place to sail his atelier boat was apparently the Petit Bras, the quiet side channel of the Seine next to the Île Marante. The boat creeps along between bushes and foliage, mirrored in the water. One oar is in the water and two occupants watch the play of the passing landscape (fig. 22). Such moments then give rise to pictures like *Autumn Effect at Argenteuil* (fig. 23), in which the fall foliage casts red and gold reflections on the river. The boundaries between earth, water, and sky are blurred. Out of apparently purely physical observation there arises an incomparable poetry of desacralized nature. Later, only Proust would be able to create, using the medium of words, comparable dreams of immobilized time. We are drawing closer to the "Raphael of water."

But first we need to return to Manet, whose dark beach scene from Berck-sur-Mer of 1873 was the last of his paintings we looked at. In the meantime, Manet had declined to participate in the exhibition of the Société anonyme coopérative des artistes peintres, sculpteurs et graveurs, organized by Monet, Degas, and others, which opened at Nadar's photographic studio on 15 April 1874. There, Monet had exhibited his 1872 painting *Impression, Sunrise*, which earned the entire movement of contemporary French plein

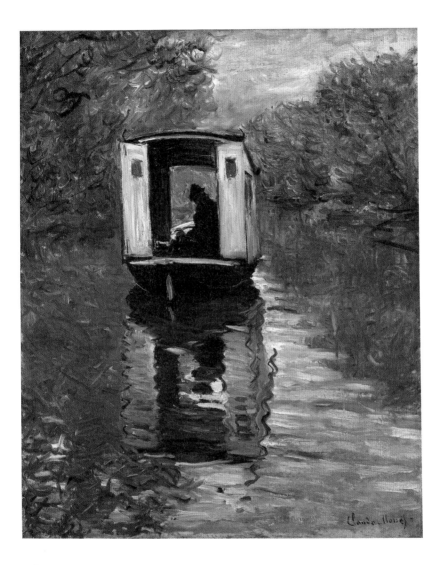

Fig. 21.
Claude Monet, *The Studio Boat*, 1876, oil on canvas.
Philadelphia, The Barnes Foundation.

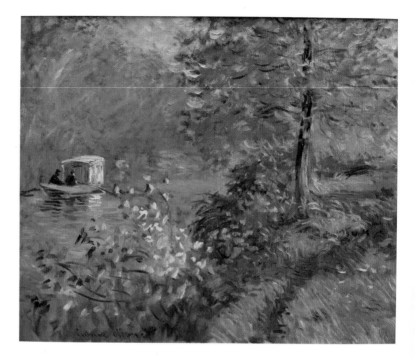

air painting the simplistic epithet "impressionism."[10] Instead, Manet continued to exhibit his work in the official Salon. But again in 1874, two of his pictures were rejected. Stéphane Mallarmé reacted on 12 April with a famous polemic in the journal *La renaissance artistique et littéraire* titled "Le jury de peinture pour 1874 et M. Manet" (The jury for painting for 1874 and Monsieur Manet).[11] Thus in the spring of 1874, in Manet's never-ending search for official recognition, he was maneuvering between the Salon and the Société anonyme to which his own, now somewhat resentful, artist-friends belonged. At this point, he may also have feared that he could be left in the dust by the latest technical experiments of his younger friends, especially the brilliantly

developed plein air painting of Monet. A turning point was reached in midsummer. When Manet took his vacation at his family's country house only a few kilometers from Argenteuil in August 1874, he paid a visit to Monet and discovered his admiration for the Raphael of water.[12]

Summer vacations, the outdoors, gardens—these were not the customary sociotope of the dyed-in-the-wool Parisian Manet. Nevertheless, in those happy weeks he achieved a receptive if also distanced rapprochement between his own work and Monet's plein air painting. Manet positively absorbs the way Monet paints, opens his own paintings

Fig. 23.
Claude Monet, *Autumn Effect at Argenteuil*, 1873, oil on canvas. London, The Courtauld Gallery.

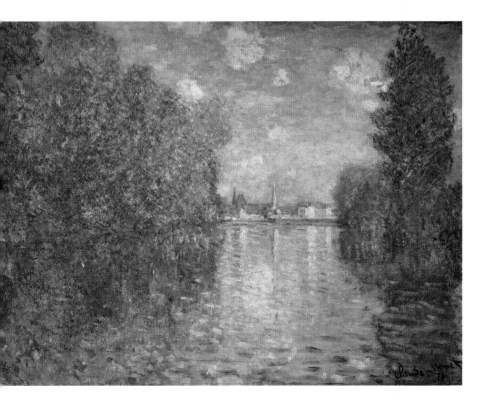

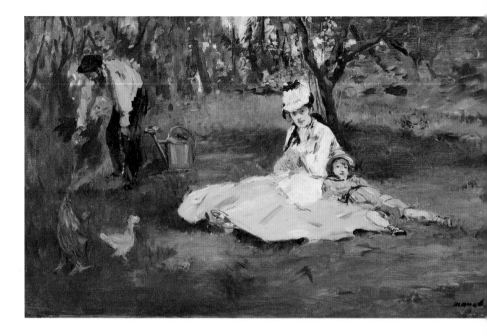

Fig. 24.
Édouard Manet, *The Monet Family in Their Garden at Argenteuil*, 1874, oil on canvas. New York, The Metropolitan Museum of Art, bequest of Joan Whitney Payson 1975 (1976.201.14).

to the light and water while remaining true to his own genuine subjects—the society of the *vie moderne*—whom he no longer paints at concerts in the Tuileries Garden, at the track at Longchamp, or at masked balls at the Opéra, but during their holidays, in boats on the Seine, with a dash of unsophisticated ordinariness.

Testimonies to their private encounter during those August days are the smaller paintings that Manet and Monet painted of each other. One of Manet's sparkling, vividly alive paintings shows Monet and his family in their garden (fig. 24). As Monet told it, "Manet, seduced by the color, the light, had undertaken to paint a picture outdoors with figures under the trees.[13] These words are a clear reference to Manet's conversion to plein air painting. Camille

Monet in a bluish-white dress, stylish hat, and red fan strikes a ladylike but coquettish pose on the lawn. Jean Monet, in his light blue sailor suit with short pants, lolls against his mother while his father—the painter, the colorist—stoops in the background, tending to his beloved flowers. Delightfully witty is the way Manet, almost as if in an animal fable, paraphrases the distribution of roles in the family in his portrayal of the poultry. The proud cock with a red comb stands at the feet of the father; the hen scurries toward the mother, and the chick belongs to the boy. Manet observes the happy family as if through a sheet of glass. Admission into this rural paradise is denied to him, the big-city boulevardier; indeed, such an admission, if granted, would rob him as an artist of the alert observer's distance he always maintained.

Monet's small picture of Manet painting outdoors, presumably also in Monet's garden, has a completely different temperature (fig. 25). The painter sits at his easel as if in an arbor, between a lattice fence and a kind of tunnel of foliage.

Fig. 25.
Claude Monet, *Manet Painting in Monet's Garden in Argenteuil*, 1874, oil on canvas. Formerly Berlin, Sammlung Max Liebermann, now lost.

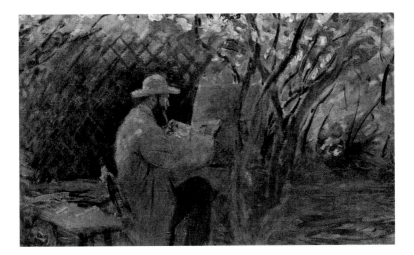

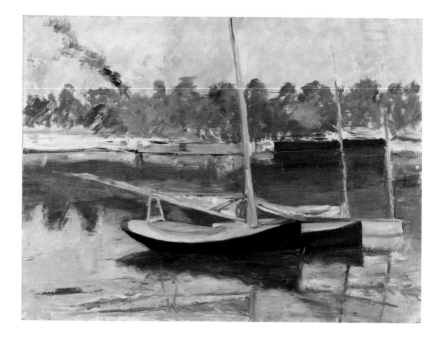

Fig. 26.
Édouard Manet, *Study of a Boat at Argenteuil*, 1874, oil on canvas. Cardiff, National Museum Wales.

Greenish-yellow light shimmers through the branches and falls on the painter, who wears a straw hat and a smock. To be sure, Monet portrayed Manet as a plein air painter, but nature encloses the artist like the walls of his studio. His posture shows him to be at work, not whiling away his time on a relaxed holiday. The painting has been lost; it once belonged to Max Liebermann, the German Impressionist who was instrumental in introducing modern French painting to Berlin.

There are two paintings by Manet from these summer weeks that one could call variations on a theme of Monet's, a subject Manet's friend had painted time and again: the marina in Argenteuil with its sailboats and the view across the river to the opposite shore (figs. 26 and 27). In what is probably the older of the two pictures

40

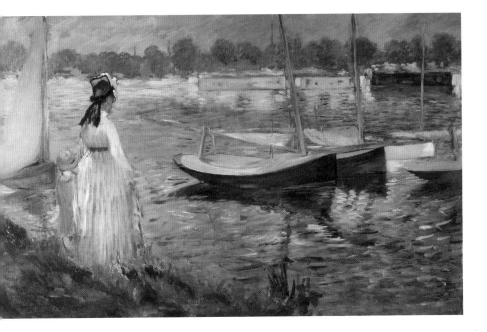

Fig. 27.
Édouard Manet, *The Banks of the Seine at Argenteuil*, 1874, oil on canvas. London, The Courtauld Gallery (on extended loan from a private collection).

(see fig. 26), Manet is still working with the technique and the palette we know from his Arcachon beach scenes of three years earlier. Stretches of dull, opaque color are dominated by tones of black and dirty brownish green. Behind the trees on the opposite shore, a smudge of sooty smoke rises from a factory stack. Industry as an ugly disturbance in the rural scenery belongs to this gloomy panorama, which is more reminiscent of some of the bleak northern suburbs of Paris than of vacation pleasures and rowing regattas. In the second painting, Manet is obviously experimenting with Monet's plein air technique, which he still finds somewhat foreign (see fig. 27). He brightens up his palette. Now the river is shining in a strong blue. Shorter—faster—brushstrokes make the reflections on its surface iridescent. Manet

is trying to paint like Monet, but with quite different results. Above all, he introduces into the depiction of landscape people arriving (or imported) from the city, thus integrating Monet's river views, which serve as his model, into his own world of images from urban society. Lonely and with nothing emphatic about her, a woman seen from behind and wearing a summer dress of white muslin and a very fashionable hat looks down at the lazily flowing water. On her left is a little girl, perhaps her daughter, who looks at the river from under a round yellow summer hat; she is as impassive as her mother. From the point of view of painterly technique, one could call this an *hommage* to Monet's plein air style. But in Manet's attempt to imitate and celebrate Monet, there is a debilitating recollection of that same vacation ennui he once captured in Arcachon, in the interior scene, with its peep-show view of the sea.

But the most important pictures that Manet painted in Argenteuil in midsummer 1874 were not landscapes. What interested the painter of the *vie moderne* in the summery suburb was the scenery of vacationers, for here he could observe and depict the social fauna of the metropolis at leisure, on vacation. And to do that, he transferred the plein air technique Monet had developed to paint nature—landscapes—onto his depiction of a society on its *vacances* and bent on escaping the customary formalities, the brilliance and the strictures of fashionable life in Paris. Thus Manet took an Impressionism that was actually foreign to him and turned it into a socially coded and very specific narrative style—or one could call it an iconographic mode: the "vacation painting." This transference is clearly demonstrated by his two best-known works from this summer of 1874: *Argenteuil* and *Boating* (figs. 28 and 29).

Argenteuil has been somewhat facilely called Manet's most
Impressionistic picture.[14] But the view of the marina and across the deep blue river to the opposite shore, with the factory smokestack already familiar to us, only provides the scenery for an erotic

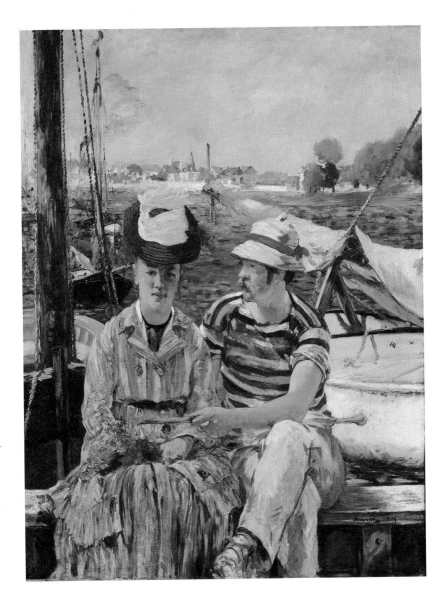

Fig. 28.
Édouard Manet, *Argenteuil*, 1874, oil on canvas.
Tournai, Musée des Beaux-Arts.

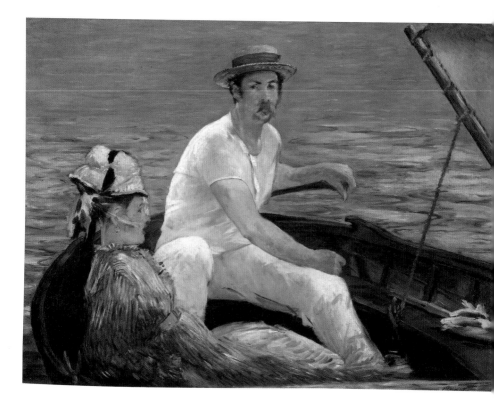

Fig. 29.
Édouard Manet, *Boating*, 1874,
oil on canvas. New York, The
Metropolitan Museum of Art.

encounter reminiscent of later urban paintings by Manet, such as *Nana* (1877) or *In the Greenhouse* (1879). But here his subjects have laid aside their fine manners and taken on an uninhibited allure. Everything about *Argenteuil*'s mustachioed man has a philandering cockiness: the sporty summer hat atop his head with its jaunty red hatband, the casual clothing—striped jersey and light pants—he wears so nonchalantly, and especially the suggestive gesture of his bare arm and hand, which grasps an umbrella like a lance and points it toward the lap of the woman next to him. She sits enthroned on a crude wooden bench on a dock, awkwardly tricked out in what is probably a cheap,

blue-and-white-striped dress with remarkably large buttons and a veritable pot of a hat on her massive head. A neglected bouquet lies in her lap. She makes a dull impression, as if she has been hired. We now know that Manet's brother-in-law Rodolphe Leenhoff served as the model for the male figure.[15] We do not know who the woman was. For her, we must rely on the succinct sentences of Manet's friend Théodore Duret: "The rowers came from various levels of society. The women they brought along were women of pleasure of the middling kind. The one in *Argenteuil* belongs to this class. But since Manet kept as closely to life as possible and never projected anything onto a face than what its nature brought with it, he depicted the rower's woman with her banal figure, sitting there idle and lazy." And then Duret closes with the blunt, laconic sentence: "He depicted the whore precisely as nature had presented her to him."[16] Manet's *Argenteuil* is certainly painted in the technique of Impressionism, but its theme is society, not water. This bold experiment to meld Monet's plein air painting with the depiction of Parisian *vie moderne* at leisure was important to Manet. He exhibited *Argenteuil* like a programmatic statement in the Salon of 1875.

Perhaps the picture's inclusion of the vulgar grisette can be better understood when we look at *Boating* (see fig. 29), Manet's second painting with a boat and figures from the Argenteuil summer of 1874. First, a striking difference: the Impressionistic technique Manet tried out in *Argenteuil* has been coolly taken back. No landscape appears; there is no hint of a location and no seductive play of light to beguile us. The lusterless blue of the water is nothing but a neutral background against which the figures are silhouetted. Once again, a man and a woman are depicted. But rather than relating flirtatiously to each other they are indifferent and maintain an almost frosty distance. They also belong to a different social class than the ordinary couple in *Argenteuil*. The man, who sits in the stern and steers the boat with the tiller, wears the getup

of the posh Cercle nautique of Argenteuil: white shirt and pants and a straw boater with a blue hatband.[17] He takes no notice of the female figure next to him; his commanding gaze is completely preoccupied with steering the sailboat. The lady seated on the bench and leaning against the side of the boat is fashionably attired. She wears a belted dress with white-and-blue stripes. Her striking hat is the same as the one Camille Monet wears in Manet's family portrait in Monet's garden. A transparent veil protects her face from the wind. With no visible emotion, she gazes across the legs of the helmsman and out onto the river.

For the somewhat snobby and dandyish man, Manet again used his brother-in-law Rodolphe Leenhoff as a model. We don't know who the woman was, but it doesn't matter, for what is at stake here is not portraiture but the social role-play taking place in the boat, observed by the urban dweller Manet during his vacation in Gennevilliers.[18] Like so many of Manet's paintings, Boating is a sharply emphatic statement about the polarity in the roles of the sexes in contemporary bourgeois society: the man, his legs spread in an assertive pose, steers the boat, while the woman finds herself relegated to a dreamy, poetic state or, worse, given over to sophisticated ennui. It is certainly no image of earthly delight. Above all, Boating demonstrates in a rough and almost violent way how selectively and reflexively Manet puts to use the Impressionist technique of his friend Monet. According to subject, according to social stratum, he allowed the technique to shine forth from one picture— Argenteuil—but coolly suppressed it in the next. From this reflexive, sovereign distance, he created during that summer in Argenteuil his most eloquent boat painting, which expresses his admiration for the Impressionist Monet by celebrating him as the Raphael of water in his floating atelier.

46

Tradition has it that during his visits to Argenteuil, Manet at first intended to paint a large portrait of Monet and his wife. Only

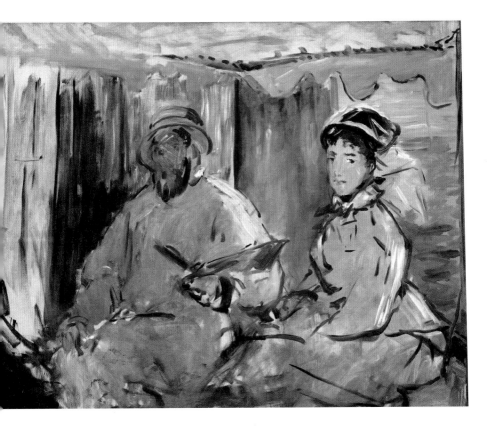

Fig. 30.

Édouard Manet, *Claude and Camille Monet*, 1874, oil on canvas. Stuttgart, Staatsgalerie.

after he had abandoned this project, supposedly because he did not want to subject his friends to long, stressful sittings, did he instead paint the couple in *Argenteuil* as a sort of substitute and then, as we have seen, exhibited the picture in the Salon of 1875 as evidence of his conversion to Impressionism.[19] In this interplay of influence, distance, and appropriation, what was always at issue was the transformation of the Impressionist representation of landscape and water into an Impressionist depiction of contemporary society.

However it may have happened, what has come down to us is a large, unfinished painting by Manet, dominated by the figures of Monet and his wife, Camille, in the atelier boat (fig. 30). Manet gave this unfinished picture to his friend Monet as a souvenir of that productive and inspiring summer of 1874. For Monet, this *ébauche* (sketch) was a powerful enough memento that it remained in his possession until his death in 1926. In order to "read" this painting, which was either a study for a work that remained unfinished or from the first was intended to remain a sketch, we need to consult a smaller picture that depicts Monet floating on the Seine in his atelier boat and working on a landscape (fig. 31). In the larger, unfinished painting, we see Monet sitting in the forward part of the boat. Behind his left shoulder, which is delineated with powerful white highlights, the edge of the cabin opening can be seen. The valance of an awning with red trim has been stretched over the bow of the vessel to protect its occupants from the summer heat and especially from the blinding light of the August sun. Monet, presented frontally in three-quarter view, wears summer clothes like the sailors and rowers: a light, probably white, shirt, pants—of linen?—with a yellowish tint, and a summer hat with a red hatband. In the crook of his left arm he holds a brush and palette, while his right hand holding the brush currently in use is lowered. He is depicted during a pause between brushstrokes. His pupils are alight. Spellbound, he gazes out at the landscape whose impression he will transfer to the large canvas, which is more suggested than depicted as a white area on the left edge of Manet's canvas. Monet will paint what he sees and he sees what he is about to paint. But it is not just a question of an optical impression. In this portrait sketch, he has the power of a demiurgic being, replete with a potency that is not only observational but also visionary, full of creative amazement at the landscape, the water, and the light.

Wearing fashionable clothes, Camille sits farther forward, on a bench by the gunwale. Her dress is nipped in at the waist, its collar decorated with a bow, and the chiffon veil of her hat is pushed back. She sits in profile but turns her face outward toward the landscape as well. While Monet's sparkling eyes bespeak the sensuously delighted gaze of the plein air painter, Camille's pale face remains without any specific expressive accent. The contrast is similar to that of *Boating*. The man, whether sailor or painter, is active, while the woman beside him is indifferent or daydreaming or beset by ennui. As we have already said, this is not the only time Manet showed men and women next to each other in such disparate moods, thereby pointing to a distribution of roles between the sexes that allows the "gentlemen" to be active while the "ladies," without any public activity, hang back—decorative, melancholy, and somewhat vacuous. We are familiar with this constellation from novels of the time, even if Camille Monet is no Emma Bovary, Effi Briest, or Dorothea Brooke and Manet presents this relationship not in a melodramatic, narrative way but rather in suggestive visual silence. After breaking off work on the double portrait of Claude and Camille Monet in the atelier boat, Manet painted *Boating*, a sporty and somewhat vapid variant of this project, but again, a picture in which the woman is shown as the idle dreamer while the man above her is directing things, with the tiller in his grasp.

The identification of the double portrait of Claude and Camille Monet as an *ébauche* is not exactly false, but it oversimplifies the process by which the picture came to be. The aforementioned tradition that Manet, loath to subject his friends to more troublesome and time-consuming sittings in the atelier boat, abandoned the project in its originally intended form already argues against an assumption that he tossed off the sketch in just a few hours. Obviously Manet was planning a major, ambitious work that would proclaim and represent the modern plein air style programmatically

Fig. 31.
Édouard Manet, *The Boat*
(Claude Monet in His Floating
Studio), 1874, oil on canvas.
Munich, Neue Pinakothek.

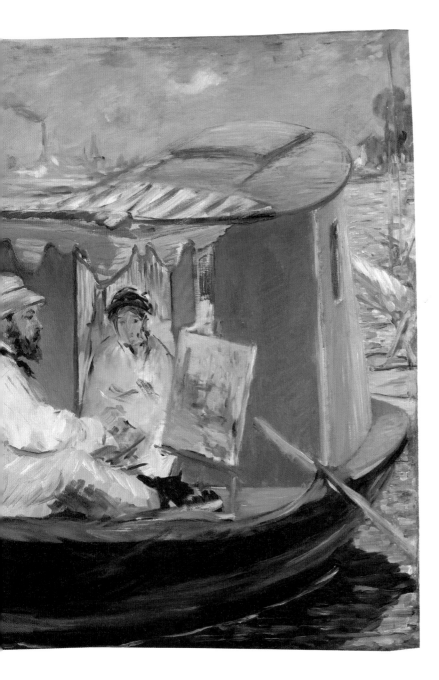

to the Parisian public in the same way that his brilliant, imposing portrait of the novelist and critic Émile Zola at his desk had done six years earlier for the literature of naturalism. Manet stopped work on the painting at a stage when only the positions and outlines of the subjects were determined but the addition of color to clarify the motifs had not yet begun. In this condition, the picture was basically unreadable. And so Manet decided to "complete" the unfinished painting in a colorless technique that, until then, he had applied only to pen-and-ink drawings or graphic works. With rapid, black brushstrokes he brought to the fore and highlighted—now working rapidly and even hastily—the most significant parts of the double portrait: Monet's beard, his left hand with the palette, the contour of his leg, Camille's eyes and eyebrows, her hair, her outline, and her dress. It was a spirited play between two techniques that transformed the abandoned painting into a sort of *peinture graphique*. A comparative glance at a Manet drawing that has survived as a woodcut and shows the legendary *salonarde* Nina de Callias can illuminate the genetics of this transfer from graphic work to painting (fig. 32). The result has the brilliance of an aperçu but also a drama unusual for Manet. Monet's figure, a barely articulated yellowish-gray mass, sinks into the depths of the picture as if he were underwater. Out of the diffuse twilight, however, the eyes of the painter who sought never the darkness but always the light sparkle forth. Camille, by contrast, is brought forward by Manet's brushstrokes into the light and the open air, and in sharp outline. Thus the brushwork subtly accentuates the inward and outward distance between the demiurgic figure of the painter and the accompanying woman sitting palely by his side. The distance between Claude and Camille is spanned by the blue wall of the cabin, a zone of longing and a field of the elemental ur-color of Monet's aquatic paintings.

52

The question of whether this painting is finished or unfinished becomes moot in view of such a conclusion. In its *non-finito*

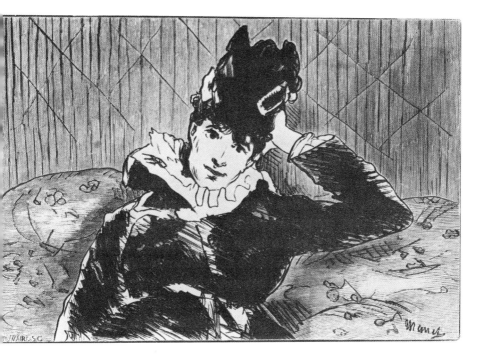

Fig. 32.

state between *peinture* and *graphisme*, the
painting has an effect that is almost eerie.
Manet never exhibited it publicly. This
quintessentially modern, fragmentary ex-
periment was not socially presentable. Yet
by making a gift to his friend Monet, the

Fig. 32.
Alfred Prunaire, *The Parisienne
(Mme de Callias)*, ca. 1910,
woodcut after a drawing by
Manet, 1873/74.

Raphael of water, of this abandoned, failed, but in its very failure
so magnificent, double portrait, Manet gave generous testimony
to how much he valued this *ébauche*. In the circle of the Paris *in-
dépendants* and *refusés*, Monet represented a much higher authority
than the official Salon jury, which was subject to the political ma-
neuverings of the art market.

But now let us turn to the other picture with Claude and
Camille Monet in the atelier boat mentioned above (see fig. 31). It

53

is probable that this painting was also made during Manet's visits to Argenteuil in August 1874, but we do not know if it was painted before or after or even in parallel with the abandoned double portrait. The question is not important, however, because the second picture has a different theme. It is less a portrait than a tribute to the plein air painter Monet, at work before his easel in the atelier boat. The vessel has been moored in the marina at Argenteuil. In the background on the left, we can see the factories across the river on the northern bank, just as they appeared in two other paintings by Manet: *Study of a Boat at Argenteuil* (see fig. 26) and especially *Argenteuil*, the picture with the flirting couple (see fig. 28). For this painting of Monet in his atelier boat, Manet apparently set up his easel at the same spot as he did for *Argenteuil*. That fact throws light on his role-play of vacationing couples in boats. For his part, he needed solid ground under his feet. With the view from the shore he gained the distance to be able to paint Monet in his floating atelier as his counterpart, his complementary other.

When this second picture was auctioned off by Manet's estate in 1884, its title was the succinct *Monet in His Studio*. This label comports with another statement of Manet's related by his friend Théodore Duret: "Monet! his studio is his boat."[20] The title of this second painting makes it clear that Manet was applying one of the most self-conscious genres in the history of European painting, the representation of the painter at work in his studio, to the new plein air style. Portraying the painter in his studio was always painting's means of self-reflection—painting reflecting on the mystery of its own mimetic creations. Manet had often had recourse to the work of his old master predecessors in his most exemplary pictures, such as *Olympia*, *Le déjeuner sur l'herbe*, *The Execution of Emperor Maximilian of Mexico*, or *The Balcony*. With the painting *The Boat (Claude Monet in His Floating Studio)*, he extended the self-reflection of painting to its then most modern form,

Impressionism. His picture of Monet painting in his atelier boat is no mere portrait, no occasional piece, but instead a visual statement in the contentious contemporary debate about the most progressive painting style. Let us try to elucidate this assertion through a brief look at four older paintings showing painters in their studios.

A panel showing Saint Luke the Evangelist drawing a portrait of Mary nursing her divine child can be regarded as an incunabulum of the painter-in-his-studio genre (fig. 33). Rogier van der Weyden painted it around 1435, perhaps for the Saint Luke altar of the Brussels painters' guild. The legend according to which Saint Luke is supposed to have painted a portrait of the Virgin Mary has been appropriated for a symbolic self-representation of Old Netherlandish painting. In the picture, Saint Luke's features are presumably those of Rogier. Moreover, instead of painting the Madonna he is making a silverpoint portrait in conformity with the contemporary practice of portraiture in the Netherlands. The balcony on which Mary sits enthroned looks out on a prospect of open landscape—a river valley, a town, and a rocky shore—which two figures, a man and a woman seen from behind, are admiring. Thus the depiction of a pious legend becomes a mirror of the visible world. This river landscape is an almost literal quotation from a painting by the most famous Old Netherlandish master, Jan van Eyck. And so Rogier's panel is both a devotional retable or epitaph and a painting about the newest painting style of its day, the *ars nova* of Old Netherlandish painters and their most famous representative, Jan van Eyck.[21]

Manet probably was not familiar with Rogier's panel. But he did know and admire another, far more famous atelier picture, which he saw during a trip to Spain in August 1865: *Las meninas* by Diego Rodríguez de Silva y Velázquez. Here Velázquez, the court painter, painted himself painting in the midst of court society. But what he is painting at this moment remains concealed from

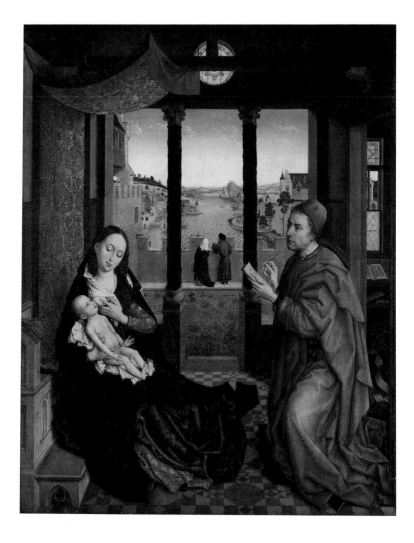

Fig. 33.
Rogier van der Weyden (studio), *Saint Luke
Painting the Virgin*, ca. 1435, oil on panel. Munich,
Alte Pinakothek.

us, like the landscape Monet is painting in the double portrait in the atelier boat. In *Las meninas*, we see only the back of a huge canvas propped up before and to the side of the painter. What is the painter, who like Monet holds his palette and brushes, looking at? Is it the picture he is working on, or the subject he is depicting, or some sudden interruption that distracts him from his painting? All possibilities remain open. Are the infanta and the court dwarf also looking at the same, apparently compelling interruption as the painter? On the wall in the background hangs a mirror whose surface reflects the royal couple just now entering the room and drawing all eyes to themselves, as etiquette and the hierarchy require. Thus *Las meninas* is a picture about the painter at court who shows us no external action, but only the mute play of glances between the members of court society and the royal couple, who are visible for us only as spectral presences, reflections in a mirror. There is much food for thought in the fact that such a highly self-conscious painter of French modernism as Manet was riveted by precisely this painting in which nothing is happening. A painting by Manet showing Velázquez in the company of two court cavaliers (fig. 34) testifies to his admiration for the Spanish master.[22]

As art liberated itself during the age of revolutions from its servitude to throne and altar, gaining new autonomy in the competitive bourgeois society, the depiction of the painter in his atelier became a programmatic image. In Gustave Courbet's famous *The Painter's Studio* of 1855, the entire society is gathered around the painter. Flanked by his model and marveled at by a child, he sits before his easel and captures on canvas the natural world as a sort of counterimage to the assembled humanity. The painter himself gave a commentary on his picture: "It is about the inner and outer history of the studio. . . . I am in the middle and I paint. On the right are those who take an interest, my friends, colleagues, art lovers. On the left is the other world, daily life, the people, misery,

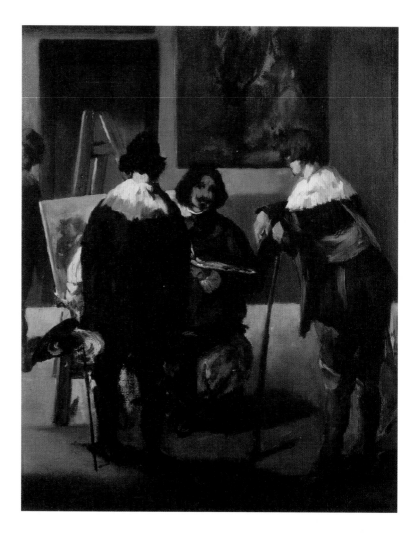

Fig. 34.
Édouard Manet, *Velázquez in the Studio*, ca. 1860, oil
on canvas. Private collection.

wealth, poverty, the exploited and the exploiters."[23] Courbet has loaded his atelier picture with melodramatic social significance. In an *"allégorie réelle"*—as he called it—he has brought the entire bourgeois society in all its diversity and contradictions into the studio of the painter, who himself stands in their midst, portraying society, just as not long before Honoré de Balzac had "narrated" it in *La comédie humaine*. In 1855, Manet was twenty-three years old. It was the last year of his apprenticeship with Thomas Couture. Of course he was aware of Courbet's colossal studio picture. It belongs to the immediate prehistory of his own picture of the plein air painter Monet in his floating atelier.[24]

Temporally and personally , Henri Fantin-Latour's *A Studio at Les Batignolles*, exhibited in the Salon of 1870 (fig. 35), is even closer to Manet's painting. A circle of modern painters and critics, in which Manet was the central figure and dominant talent, had been meeting in the Café Guerbois on the grand rue des Batignolles near the place Clichy since 1866. Fantin-Latour was one of Manet's admirers. In the Salon of 1867, he had exhibited an extremely elegant and utterly bourgeois portrait of Manet with top hat, watch chain, and expensive leather gloves, and he gave it the emphatic dedication "À mon ami Manet."[25] That portrait was already a public declaration of loyalty to the controversial painter of the *Olympia*, and in *Studio at Les Batignolles*, Fantin-Latour's loyal partisanship is raised to the level of a veritable profession of faith. Surrounded by the painters and critics who were his comrades-in-arms—Bazille, Renoir, and Monet, as well as Zola—Manet sits before his easel with palette and brushes in his hands and paints the portrait of his sitter, the critic Zacharie Astruc. In their dark suits, these artists and writers look hardly different from academics, and even more like lawyers or men of business. Not a hint of bohemianism, not a touch of artistic allure or poetic inspiration. This dust-free atelier picture is as dry and sober as a group photograph. It shows

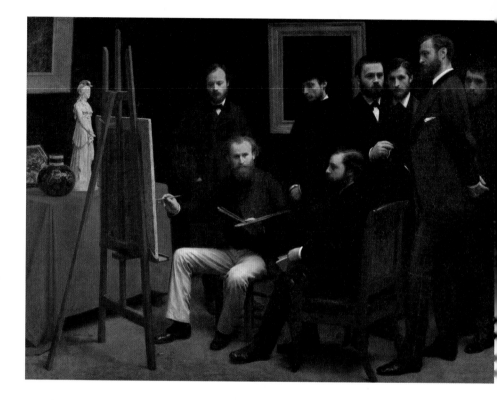

Fig. 35.
Henri de Fantin-Latour, *A Studio at Les Batignolles*, 1870, oil on canvas. Paris, Musée d'Orsay.

the protagonists of modern painting and literature in the midst of the bourgeois world, and it is precisely thereby an homage to Manet as the leading artist of the *vie moderne*.

Four years later, Manet will transfer the traditional atelier picture out onto the water and under the open sky. In the course of this liberating act, he will certainly have recalled the tribute Fantin-Latour had paid him with *Studio at Les Batignolles*. It has even been rather unconvincingly suggested that the placement of Claude and Camille Monet in the *ébauche* (see fig. 30) was inspired by the two figures of Manet and his sitter Astruc.[26] But

let us now return to Manet's second picture of his younger friend in the atelier boat (see fig. 31). Seemingly a mere holiday painting from that happy summer in Argenteuil, Manet's homage to Monet in his floating studio is a programmatic picture in a more subtle, artistic sense than the preceding atelier pictures of Courbet and Fantin-Latour. Here, the painter appears free of all social obligations, an escapee from the bustle of society and business in the nearby capital, liberated from the bonds of literary texts that dictated the academic subjects for artists. Now, he paints nothing but the landscape and its mirrorings and reflections on the water. He appears in the floating condition that Manet captured in his aperçu about the Raphael of water. But the aquatic, deracinated, free-floating mode of existence of the Impressionist painter is being depicted by an artist who, although full of admiration and amiable respect in this painting, is by no means a participant in it himself.

It is an eye full of sympathy, but nevertheless an outsider's eye that Manet casts on the plein air painter emancipated from all tradition. What is taking place here between Manet and Monet, before our eyes, is a sensitive play between fascination and distance. Manet's witty bon mot "Il est le Raphaël de l'eau" also resonates with the superior irony of a cosmopolitan observer.

But let us take a closer look at the picture itself. It depicts a summer day on the Seine. The flowing water of the river, which here widens into a leisurely curve, shimmers in saturated blue with white and dark greenish reflections—radiant to be sure, but also opaque and massy. In the sky, clouds mix with the smoke from the factory stacks of Argenteuil. On the left, we see a piece of the bank in Gennevilliers with houses and a boat, a motif familiar from Monet's landscapes.[27] Somewhere on this riverbank, Manet has set up his easel, probably, as mentioned above, on the dock of the marina, not far from the Argenteuil road bridge. Of course, viewers of the painting cannot see or understand from where Manet

observed and painted Monet's atelier boat, but we are not supposed to be able to do so, for the view of the artist at work in his floating studio thereby acquires something of an unexpected apparition—a latter-day Raphael on the water.

To be able to give an adequate representation of Monet in his atelier boat, Manet paints like Monet. Using Monet's plein air technique, he paints the water, the sky and the clouds, the smoke, and the sailboats one can spot on the river and in the harbor. But he made sure to have sturdy scaffolding in the middle of the picture. The side of the boat, the mast that rises from the bow, the edge of the awning with its valance, and the yellow corner of the cabin constitute the borders of a picture within the picture in which only the painter, his wife, and the painting on the easel have a place. Here Manet paints like Manet, making the walls of the cabin into surfaces of lusterless blue. Thus he plays the two styles—his own and Monet's—against each other. Everywhere around the painting's periphery, where the flowing water and the open air embrace the boat, he paints like Monet. But for the walls of the cabin, before whose opening the plein air painter Monet is painting his landscape in the Impressionist style, Manet makes use of his own non-transparent manner, thereby bringing the floating picture to a standstill. For the long sittings under Manet's gaze, the boat was of course made fast to a dock. One oar is in the water and the bow is turned not into the current but toward the shore. The atelier boat gliding along on the river, as we have seen it in the pictures painted by Monet himself (see figs. 20–22), has here become a stationary atelier on the water.[28] The painting of Monet in his atelier boat, which to a superficial eye presents itself as the impression of a moment, upon further and closer inspection is revealed to be a planned arrangement, an intelligently thought-out and almost geometric composition. The observing and perhaps even vexed gaze of the outsider Manet keeps the plein air painter at arm's length and,

precisely from this distance, lends him exemplary significance. He becomes one of those key figures of the *vie moderne* we encounter in Manet's oeuvre, from *Street Singer* (1862) to *Bar at the Folies Bergère* (1881–82).

But the play of the two painting styles, his own and the one he quotes in homage to his friend, is even more subtle. The striking distribution of roles between the sexes that we have observed in other paintings by Manet from that summer—especially in *Argenteuil* (see fig. 28) and *Boating* (see fig. 29)—is resolved in dreamlike poetry in this atelier picture. Claude and Camille have here exchanged the places they occupy in the double portrait (see fig. 30). Now it is Monet, the man and practicing artist, who sits in the open in the forward part of the boat. Camille, however, appears beyond the cabin door, almost like a being from another world. In a space filled with both light and twilight, she is poised between the figure of the painter and his canvas on the easel, looking out at the river or the shore, and one is tempted to call her the painter's muse if such a mythological comparison were still permissible in the bright, rationally illuminated world of modern plein air painting. For this part of his picture—Camille in the cabin—Manet again employs an extremely hasty, sketchy technique. In view of such passages, some have asked whether this picture of Monet in the atelier boat is even finished. But it is an ignorant question. In the progressive art of the late nineteenth century, paintings are open processes, never definitively completed but instead brought to a halt at some particularly eloquent moment. The triad of the painter Monet, his "muse" Camille, and his picture on the easel is an almost symbolic constellation in which gazing, painting, and watching enter into a happy association.

Monet is presented in pure profile and in a classic pose reminiscent of *Déjeuner sur l'herbe*, Manet's famous picture from the 1860s. As is common in Manet's work, the memory of figure placements from premodern tradition underlies the modern, contemporary

costuming. Monet wears summery clothes similar to those in the sketch-like double portrait: a white shirt with a black tie, the yellow pants of light material favored by contemporary Parisians during the warm vacation months, and a bright, almost golden hat trimmed in red. This quite genteel vacation outfit makes the artist into a bright, luminous, even radiant figure. He dominates the entire broad panorama of river, shore, and sky, capturing its impression in his paintings and transferring it into an artistic reflection. Remarkably enough, the painter takes no notice at all of Camille in the cabin. Here, the assignment of gender roles again comes into play. Monet is completely absorbed in his work. As before in the double portrait, he is depicted in a contemplative pause between brushstrokes. But here, instead of gazing out at the landscape, he critically regards the results of his work. Just like the artists in Fantin-Latour's atelier picture, this plein air painter shows not the slightest hint of the bohemian. He does not affect artistic mannerisms or indulge in romantic dreaminess in the face of nature. He is nothing but its observer. We who look at this picture see not the landscape but only its diffuse optical reflection on the canvas. But precisely thereby, we become admiring witnesses to Monet's creative process in both its scientific and poetic aspects. Our astonished eye marvels at the open air painter at work.

We are coming to the end of our discussion. At a less lofty level of discourse, Manet's bon mot "Il est le Raphaël de l'eau" belongs to the same class of antiacademic, "secessionist" comments as Max Liebermann's famous dictum, "A well-painted turnip is just as good as a well-painted Madonna"[29] (at least if one ignores the typically Berlin irreverence of the comparison, which would hardly have passed the lips of the Parisian Manet). In both cases, what is at stake is the liberation of contemporary, autonomous painting from the excess baggage of a long since moribund iconography. The Raphael of water no longer paints river gods, only the reflections of

light and color on the streams and ponds of a desacralized nature, but he does it as perfectly as Raphael once painted the Madonna.

But Manet continued that Monet knew water "in its movements, its depths, at all hours."[30] And indeed, the colorful reflections of light on water were the inexhaustible main theme of Monet's painting. He observed these reflections at the seashore, on the poplar- and shrubbery-bordered rivers of the Île de France, on the Thames in London, on the canals in Venice, and finally—long after Manet's death and the end of Impressionism—on the lily ponds of his garden in Giverny (fig. 36).[31] No mythological creatures rise from the opalescent, aquatic mirrors of his garden pictures of the water lilies under the Japanese bridge in Giverny; no mermaids lure men into the depths. The legends that have been woven around water since ancient times have long since faded away. But here is the unheard-of paradox: as an artist in a time of exact science, Monet demythologized water while at the same time salvaging the poetry of water and carrying it into modernism. Let us recall that the Latin and French words for water lily—*nymphaea* and *nymphéa*—resonate etymologically with the memory of the legends surrounding the nymphs. Like a distant dream, that memory floats above the kaleidoscopic colors of Monet's garden pictures as an associative allusion. When we look at one of these seductive paintings—or at the photograph of Monet shortly before his death, standing on the Japanese bridge above the water and the water lilies, surrounded by a profusion of plant life (fig. 37)—words of poetry echo in our ears—not of Ovid's *Metamorphoses* but rather lines from Mallarmé's poem "Le nénuphar blanc":

those magical, closed water lilies which
spring up suddenly, enveloping nothingness with
their hollow whiteness, formed from untouched
dreams, from a happiness that will never take place[32]

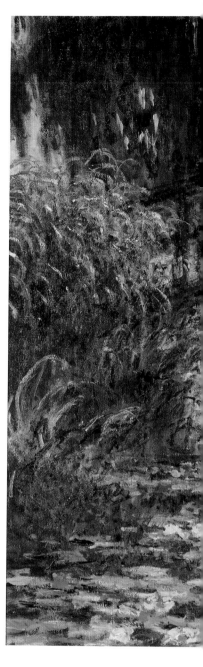

Fig. 36.
Claude Monet, *Water Lily Pond*, 1900, oil on canvas, 89.8 × 101 cm (35⅜ × 39¾ in.). Chicago, The Art Institute of Chicago, Mr. and Mrs. Lewis Larned Coburn Memorial Collection, 1933.441.

67

What remains of the nymphs of legend in the modern world is only the water lily as a floral dream of happiness that will never be fulfilled. The poet speaks of this dream in his verses; the painter evokes it in his pictures. Manet, the *vie moderne*, the happy summer of 1874 in Argenteuil—they all lie far in the past. The Raphael of water from the bright, optimistic days of early Impressionism no longer paints sailboats, bridges, and his own floating atelier. In the loneliness of old age, he discovers and depicts the unfathomability of the water in his lily ponds as an ur-element of life.

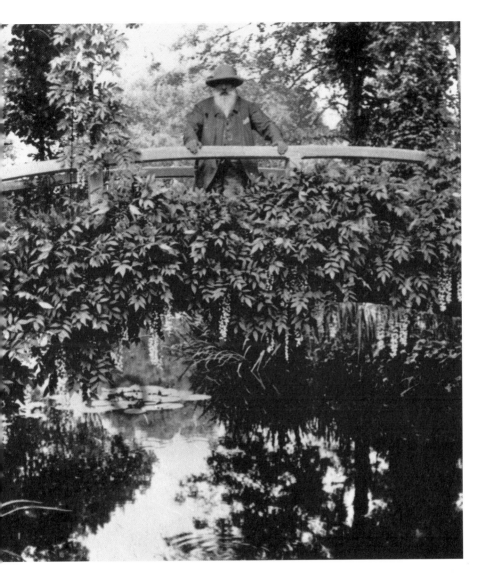

Fig. 37.
Painter Claude Monet on the Water Lily Bridge at Giverny, 1920s, photograph.

AFTERWORD

This text began as a lecture for the Friends of the Alte Pinakothek in Munich in the summer of 2004. It has been expanded for print and takes into account the literature that has appeared in the meantime; Ina Conzen's Stuttgart catalogue, *Édouard Manet und die Impressionisten*, proved especially helpful in this regard. Heartfelt thanks go to Maria Vollmann, who located the secondary sources and produced the clean copy, to Reinhold Baumstark, who lent his expert advice on the layout, and to my dedicated editor, Stefanie Hölscher.

In view of the enormous increase in the quantity and quality of work on the history of art in the nineteenth century that we have experienced in the wake of postmodernism, this study of the progressive poetry of the Parisian *peinture de la vie moderne* after 1870 was a welcome and unseasonable pleasure that I hope will provide some enjoyment to its readers.

—W.S.

NOTES

1. Juliet Wilson-Bareau, *Manet par lui-même: Correspondance et conversations, peintures, pastels, dessins et estampes* (Paris: Editions Atlas, 1991), 55–65.

2. "On fait ses délices du cheval, l'âne est hors de prix, il y a des boucheries de chiens de chats et rats." Wilson-Bareau, *Manet par lui-même*, 60.

3. For the two lithographs, see Theodore Reff, *Manet and Modern Paris: One Hundred Paintings, Drawings, Prints, and Photographs by Manet and His Contemporaries*, exh. cat. (Washington, D.C.: National Gallery of Art/Chicago: University of Chicago Press, 1982), 200–209; and Juliet Wilson-Bareau, "Manet und die Erschießung Kaiser Maximilians," in Manfred Fath and Stefan Germer, eds., *Édouard Manet: Augenblicke der Geschichte*, exh. cat. (Mannheim: Städtische Kunsthalle/Munich: Prestel, 1992), 103–31.

4. On Manet's visit to Arcachon, see Wilson-Bareau, *Manet par lui-même*, 160–61. See also Juliet Wilson-Bareau and David C. Degener, *Manet and the Sea*, exh. cat. (Philadelphia: Philadelphia Museum of Art/New Haven: Yale University Press, 2003).

5. "Ce jeune homme veut faire du plein air, comme si les Anciens y avaient jamais songé." For this remark, see Hélène Adhémar, "Hommage à Monet," in Hélène Adhémar, ed., *Hommage à Claude Monet (1840–1926)*, exh. cat. (Paris: Grand Palais/Paris: Éditions de la Réunion des Musées Nationaux, 1980), 15.

6. See Wilson-Bareau, *Manet par lui-même*, 169. In the French original: "Il est le Raphaël de l'eau. Il la connaît dans ses mouvements, dans toutes ses profondeurs, à toutes ses heures."

7. For Monet's garden in Argenteuil, see Christoph Becker, "Monets Garten," in Christoph Becker, ed., *Monets Garten*, exh. cat. (Zurich: Kunsthaus Zürich/Ostfildern-Ruit: Hatje Cantz, 2004), 23–27; and Paul Hayes Tucker, *The Impressionists at Argenteuil*, exh. cat. (Washington, D.C.: National Gallery of Art/New Haven: Yale University Press, 2000).

8. For Monet's atelier boat, see Ina Conzen, *Édouard Manet und die*

Impressionisten, exh. cat. (Stuttgart: Staatsgalerie/Ostfildern-Ruit: Hatje Cantz, 2002), 73–81.

9. For Daubigny's boat, see Conzen, *Édouard Manet und die Impressionisten*, 79.

10. For this painting, see Adhémar, *Hommage à Monet*, 139 (no. 45).

11. See Stéphane Mallarmé, *Œuvres complètes*, ed. Henri Mondor and Georges Jean-Aubry (Paris: Gallimard, 1945), 695–700.

12. With regard to this, see Tucker, *The Impressionists at Argenteuil*, 26.

13. "Manet, séduit par la couleur, la lumière, avait entrepris de faire un tableau en plein air avec des personnages sous les arbres." For this quote, see Françoise Cachin, Charles Moffett, and Michel Melot, eds., *Manet, 1832–1883*, exh. cat. (Paris: Grand Palais/Paris: Éditions de la Réunion des Musées Nationaux, 1983), 360.

14. Cachin, Moffett, and Melot, *Manet, 1832–1883*, 353–55 (no. 139).

15. Cachin, Moffett, and Melot, *Manet, 1832–1883*, 353.

16. "Les canotiers venaient de mondes différents, mais les femmes qu'ils emmenaient avec eux n'appartenaient qu'à la classe des femmes de plaisir de moyenne condition. Celle de l'*Argenteuil* est de cet ordre. Or comme Manet, serrant la vie d'aussi près que possible, ne mettait jamais sur le visage d'un être autre chose que ce que sa nature comportait, il a représenté cette femme du canotage, avec sa figure banale, assise oisive et paresseuse. Il a bien rendu la grue que l'observation de la vie lui offrait." See Cachin, Moffett, and Melot, *Manet, 1832–1883*, 353.

17. See Conzen, *Édouard Manet und die Impressionisten*, 86–87.

18. For the identification of the sailor as Rodolphe Leenhoff, see Cachin, Moffett, and Melot, *Manet, 1832–1883*, 356.

19. See Cachin, Moffett, and Melot, *Manet, 1832–1883*, 353.

20. "Monet! son atelier, c'est son bateau." Théodore Duret, *Histoire de Édouard Manet et de son œuvre* (Paris: Charpentier et Fasquelle, 1906), 161.

21. For the copy of Rogier's panel in Munich, see Martin Schawe, *Alte Pinakothek: Altdeutsche und altniederländische Malerei* (Ostfildern-Ruit: Hatje Cantz, 2006), 352.

22. There is a vast literature on Velázquez's *Las meninas*. I will cite here only the lucid analysis in Martin Warnke, *Velázquez: Form und Reform* (Cologne: DuMont, 2005), 152–62. For Manet's painting *Velázquez in His Studio*, see Denis Rouart and Daniel Wildenstein, *Édouard Manet: Catalogue raisonné, 1; Peinture* (Lausanne: La Bibliothèque des Arts, 1975), 44 (no. 25).

23. "C'est l'histoire morale et physique de mon atelier. . . . Je suis au milieu

peignant. À droite sont les actionnaires, c'est à dire les amis, les travail-leurs, les amateurs du monde de l'art. À gauche, l'autre monde de la vie triviale, le peuple, la misère, la pauvreté, la richesse, les exploités, les ex-ploiteurs." See Petra Ten-Doesschate Chu, *Correspondance de Courbet* (Paris: Flammarion, 1996), 121.

24. For Courbet's atelier, see Werner Hofmann, *Das Atelier: Courbets Jahrhun-dertbild* (Munich: C. H. Beck, 2010).

25. For Fantin-Latour's portrait of Manet, see Douglas W. Druick and Michel Hoog, eds., *Fantin-Latour*, exh. cat. (Paris: Grand Palais/Paris: Éditions de la Réunion des Musées Nationaux, 1982), 194–98 (no. 68).

26. For *A Studio at Les Batignolles*, see Druick and Hoog, *Fantin-Latour*, 205–10 (no. 73). For the comparison between the couple in the double portrait in Stuttgart and Manet and Astruc in *A Studio at Les Batignolles*, see Conzen, *Édouard Manet und die Impressionisten*, 78; Conzen also does not find the comparison convincing.

27. Daniel Wildenstein, *Claude Monet: Biographie et catalogue raisonné*, 1, 1840–1881; *Peintures* (Lausanne: La Bibliothèque des Arts, 1974), nos. 337, 338, 369, 371. We can recognize one of these pictures on the easel Monet has set up in his atelier boat. With regard to this, see Conzen, *Édouard Manet und die Impressionisten*, 77.

28. Wildenstein, *Claude Monet*, nos. 316 and 253 show the marina in Argen-teuil with Monet's atelier boat tied up by the shore.

29. Max Liebermann, *Die Phantasie in der Malerei: Schriften und Reden*, ed. Günter Busch (Frankfurt am Main: Fischer, 1978), 49.

30. In this version of the quote, I follow Conzen, *Édouard Manet und die Impres-sionisten*, 78; cf. n. 6, above.

31. For the water lily pictures that Monet painted in his garden in Giverny, see Christoph Becker, ed., *Monets Garten*, exh. cat. (Zurich: Kunsthaus Zürich /Ostfildern-Ruit: Hatje Cantz, 2004).

32. ces magiques nénuphars clos qui
y surgissent tout à coup, enveloppant de leur creuse
blancheur un rien, fait de songes intacts, du bonheur
qui n'aura pas lieu

 English translation by Henry Weinfield in Stéphane Mallarmé, *Collected Poems* (Berkeley: University of California Press, 1995), also available online at http://www.nybg.org/exhibitions/2012/monet/poetry/mallarme2-popup.php.

ILLUSTRATION CREDITS

The following sources have granted permission to reproduce illustrations in this book:

Cover, frontispiece, figs. 18, 31, 33. © Blauel/Gnamm—ARTOTHEK

Fig. 2. Robert D. Farber University Archives & Special Collections Department, Brandeis University

Figs. 3, 26. National Museum Wales / The Bridgeman Art Library

Figs. 4, 36. Photography © The Art Institute of Chicago

Figs. 5, 7, 20, 22, 30. Photo: akg-images

Fig. 6. Courtesy Foundation E. G. Bührle Collection

Figs. 8, 16, 29. © Peter Willi—ARTOTHEK

Fig. 9. Photo: Hervé Lewandowski. © RMN-Grand Palais / Art Resource, NY

Fig. 10. Photo credit: Yale University Art Gallery / Art Resource, NY

Fig. 11. Photo credit: The Philadelphia Museum of Art / Art Resource, NY

Fig. 12. © National Gallery, London / Art Resource, NY

Fig. 14. Courtesy National Gallery of Art, Washington

Fig. 15. © CAP / Roger-Viollet

Figs. 17, 19. © Christie's Images Ltd—ARTOTHEK

Fig. 21. Image © 2014 The Barnes Foundation

Fig. 23. © Samuel Courtauld Trust, The Courtauld Gallery, London, UK / The Bridgeman Art Library

Fig. 24. Image © The Metropolitan Museum of Art

Fig. 28. Musée des Beaux-Arts / The Bridgeman Art Library

Fig. 35. © IMAGNO—ARTOTHEK

Fig. 37. Credit: Photo12

CONTRIBUTORS

Willibald Sauerländer taught art history at the Universität Freiburg. He was director of the Zentralinstitut für Kunstgeschichte in Munich and honorary professor at the Universität München. He has been a visiting professor at the Collège de France, Paris; Harvard University; New York University; the Scuola Normale Superiore, Pisa; and the University of California, Berkeley; and he was a Mellon Lecturer at the National Gallery of Art, Washington, D.C. His books include *Gothic Sculpture in France, 1140–1270* (1972), *Cathedrals and Sculpture* (1999–2000), *Romanesque Art Problems and Monuments* (2004), and *The Catholic Rubens: Saints and Martyrs* (2014).

David Dollenmayer is a literary translator and emeritus professor of German at the Worcester Polytechnic Institute in Worcester, Massachusetts. He is the author of *The Berlin Novels of Alfred Döblin* (1988) and has translated works by Rolf Bauerdick, Bertolt Brecht, Elias Canetti, Peter Stephan Jungk, Michael Kleeberg, Michael Köhlmeier, Perikles Monioudis, Anna Mitgutsch, Mietek Pemper, and Hansjörg Schertenleib. He is the recipient of the 2008 Helen and Kurt Wolff Translator's Prize (for Moses Rosenkranz's *Childhood: An Autobiographical Fragment*) and the 2010 Translation Prize of the Austrian Cultural Forum in New York (for Michael Köhlmeier's *Idyll with Drowning Dog*, forthcoming from Ariadne Press).

Books Published by the Getty Research Institute

The Catholic Rubens: Saints and Martyrs
Willibald Sauerländer. Translated by David Dollenmayer
ISBN 978-1-60606-268-5 (hardcover)

Display and Art History: The Düsseldorf Gallery and Its Catalogue
Thomas W. Gaehtgens and Louis Marchesano
ISBN 978-1-60606-092-6 (paper)

Futures and Ruins: Eighteenth-Century Paris and the Art of Hubert Robert
Nina L. Dubin
ISBN 978-0-89236-023-0 (hardcover)

Printing the Grand Manner: Charles Le Brun and Monumental Prints in the Age of Louis XIV
Louis Marchesano and Christian Michel
ISBN 978-0-89236-980-5 (hardcover)

Sculpture and Enlightenment
Erika Naginski
ISBN 978-0-89236-959-1 (hardcover)

Dilettanti: The Antic and the Antique in Eighteenth-Century England
Bruce Redford
ISBN 978-0-89236-924-9 (hardcover)

Titian Remade: Repetition and the Transformation of Early Italian Art
Maria H. Loh
ISBN 978-0-89236-873-0 (hardcover)